Christina Rose

Dot To Dot
Unicorns

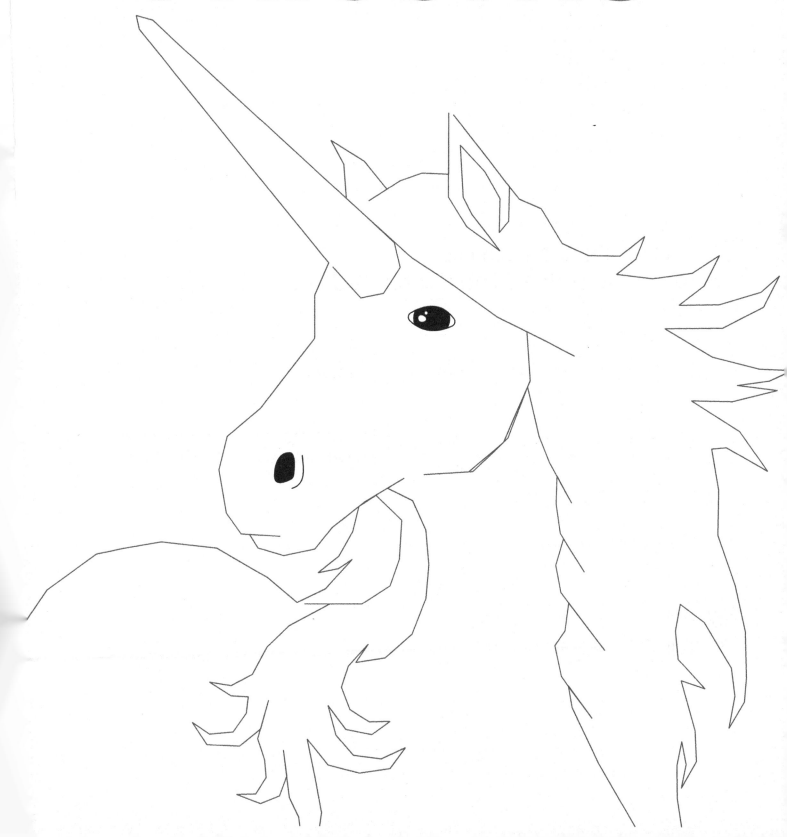

Dot To Dot Unicorns
Connect The Dots In The Enchanted World Of Unicorns
Created by Christina Rose

ISBN: 978-1-911219-63-7

BELL & MACKENZIE
PUBLISHING LIMITED
www.bellmackenzie.com

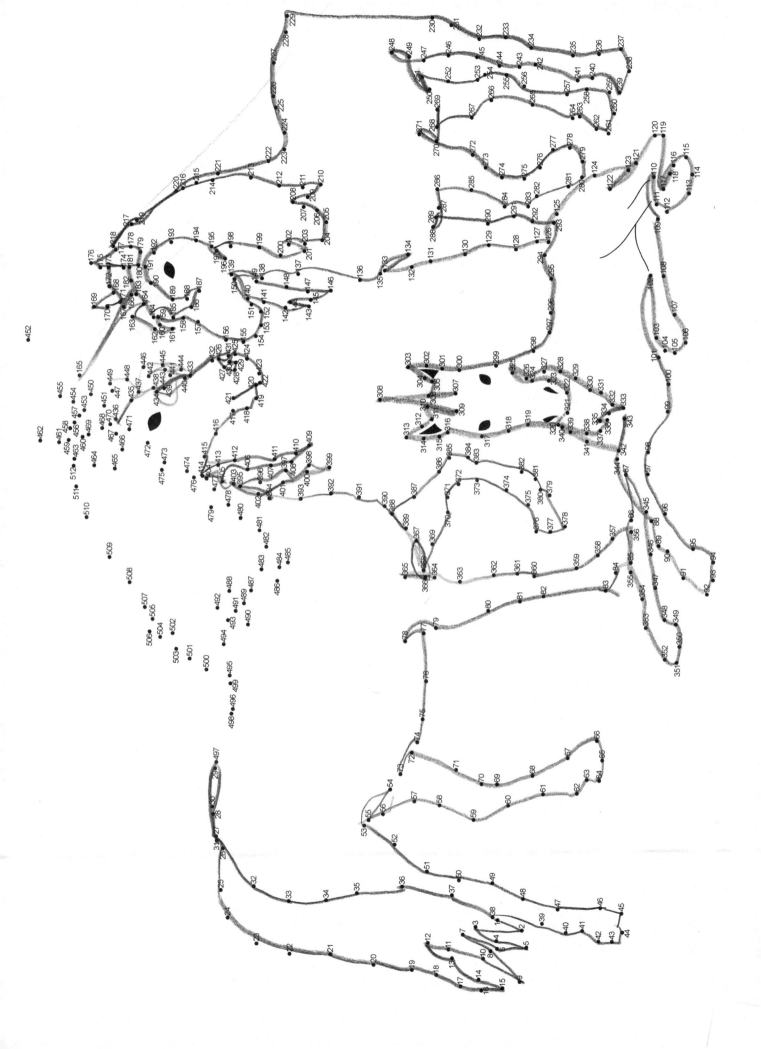

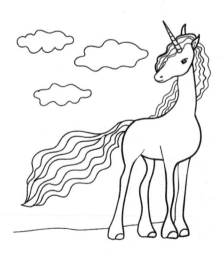

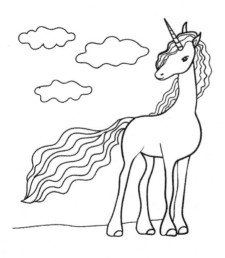

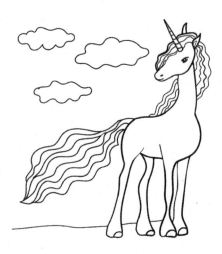

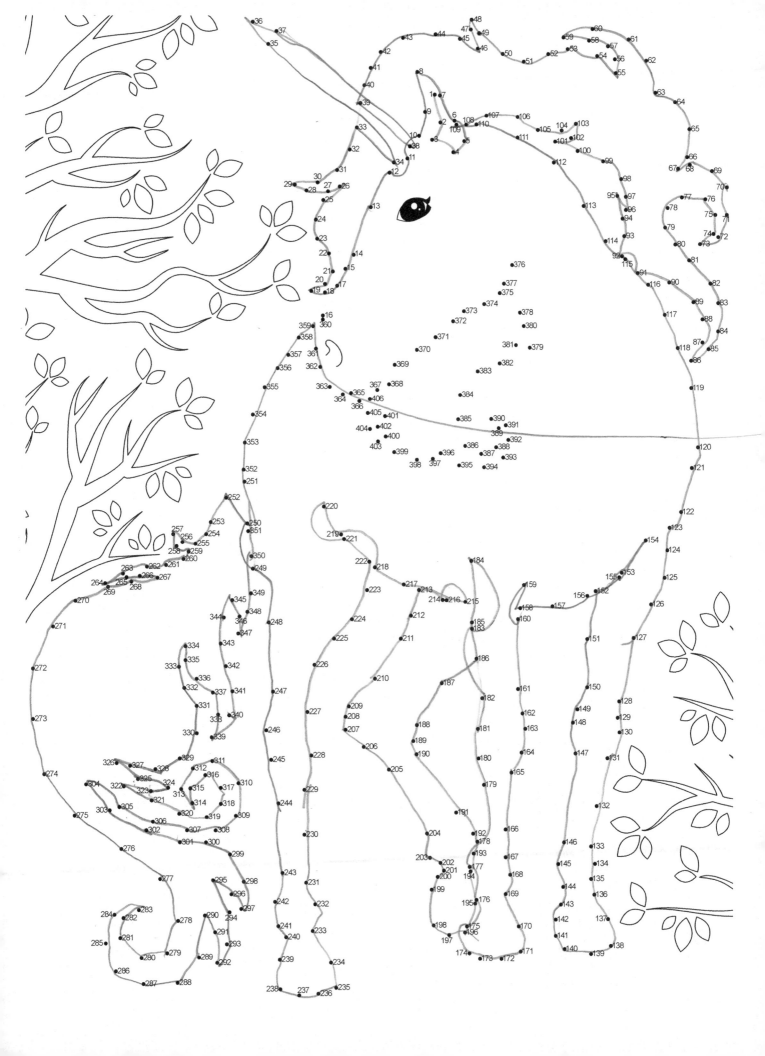

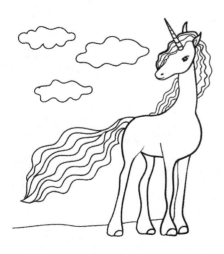

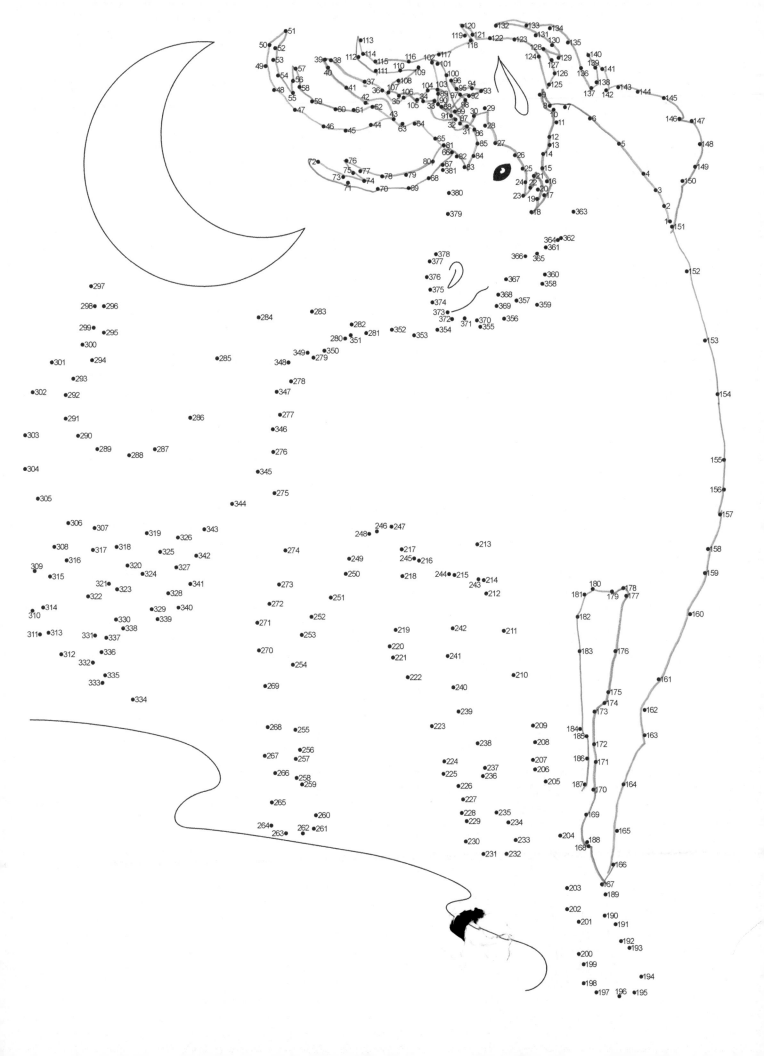

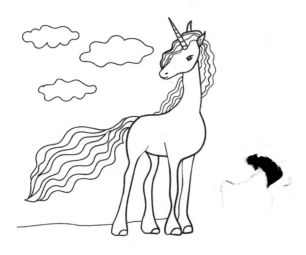

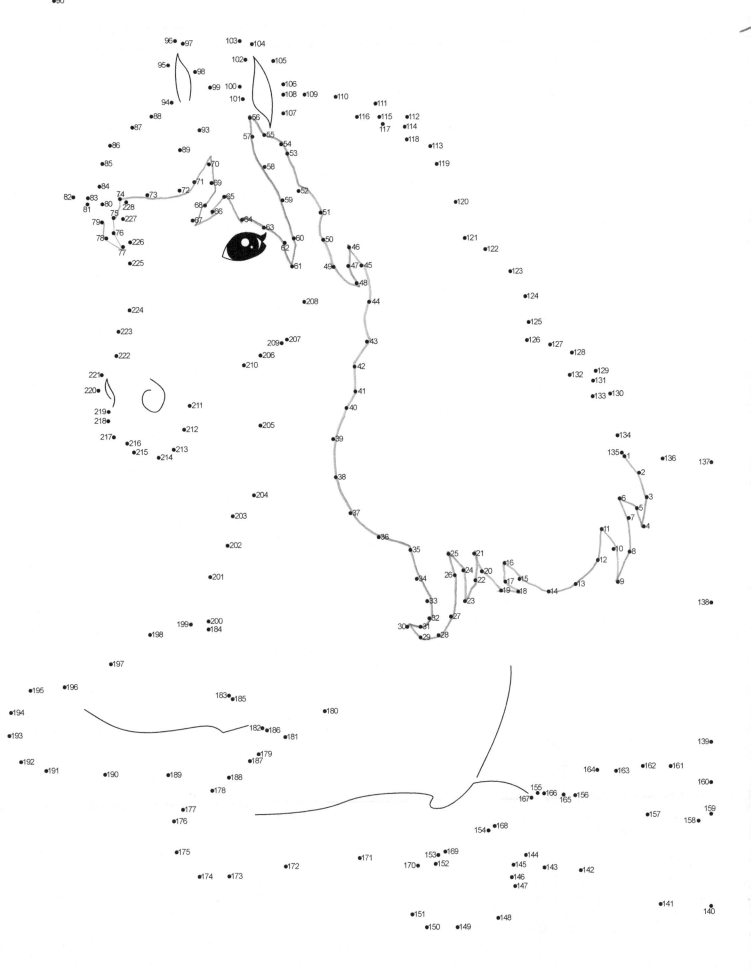

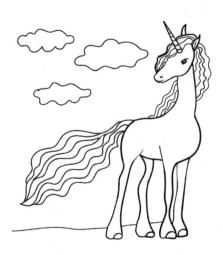

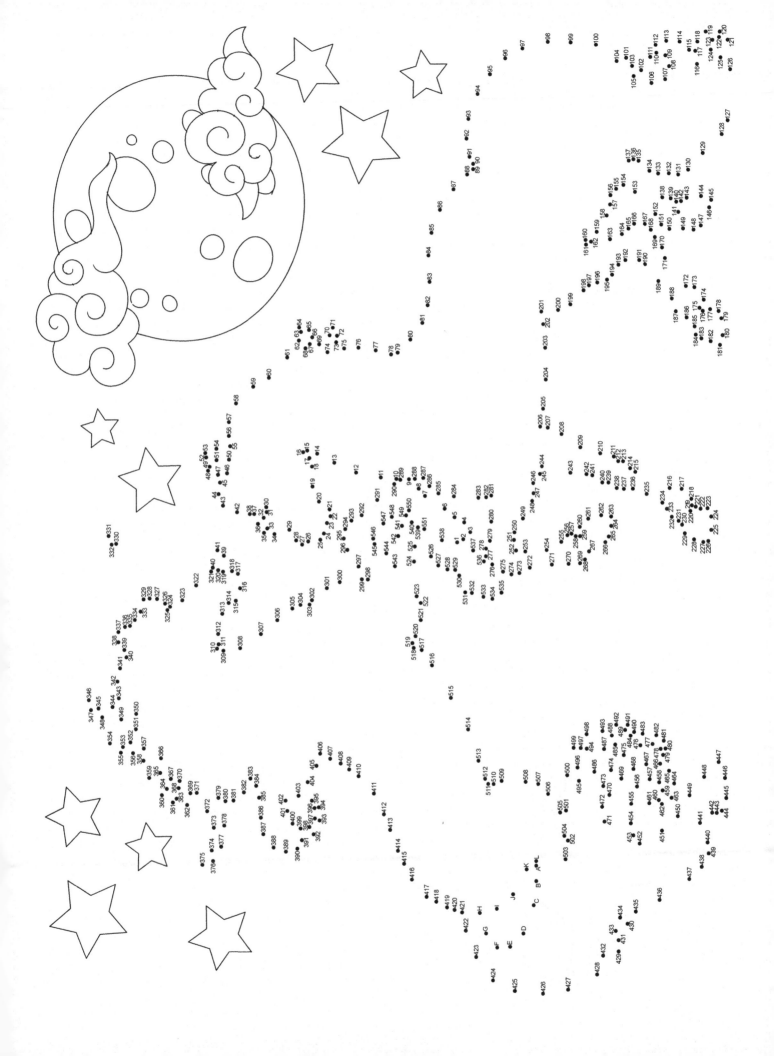

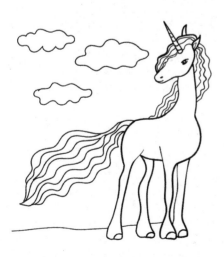

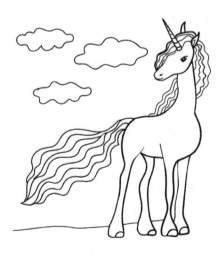

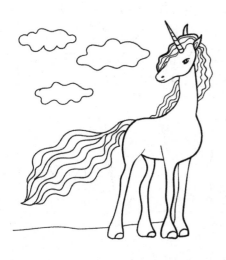

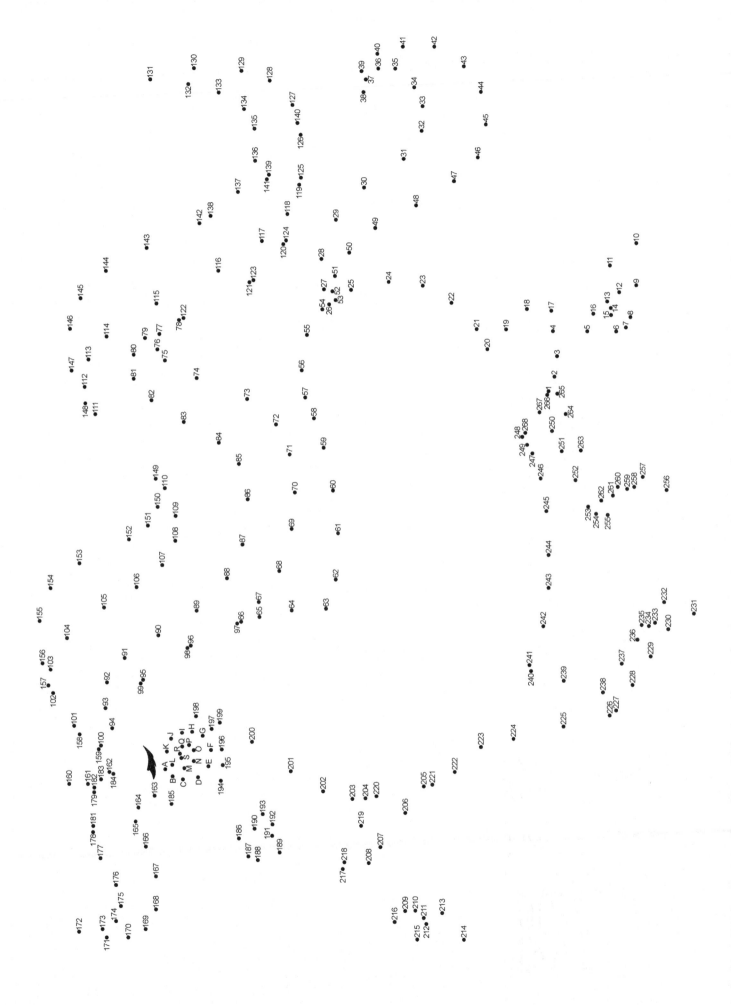

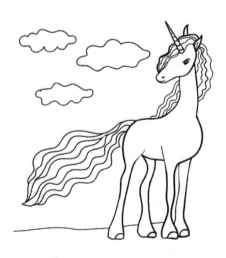

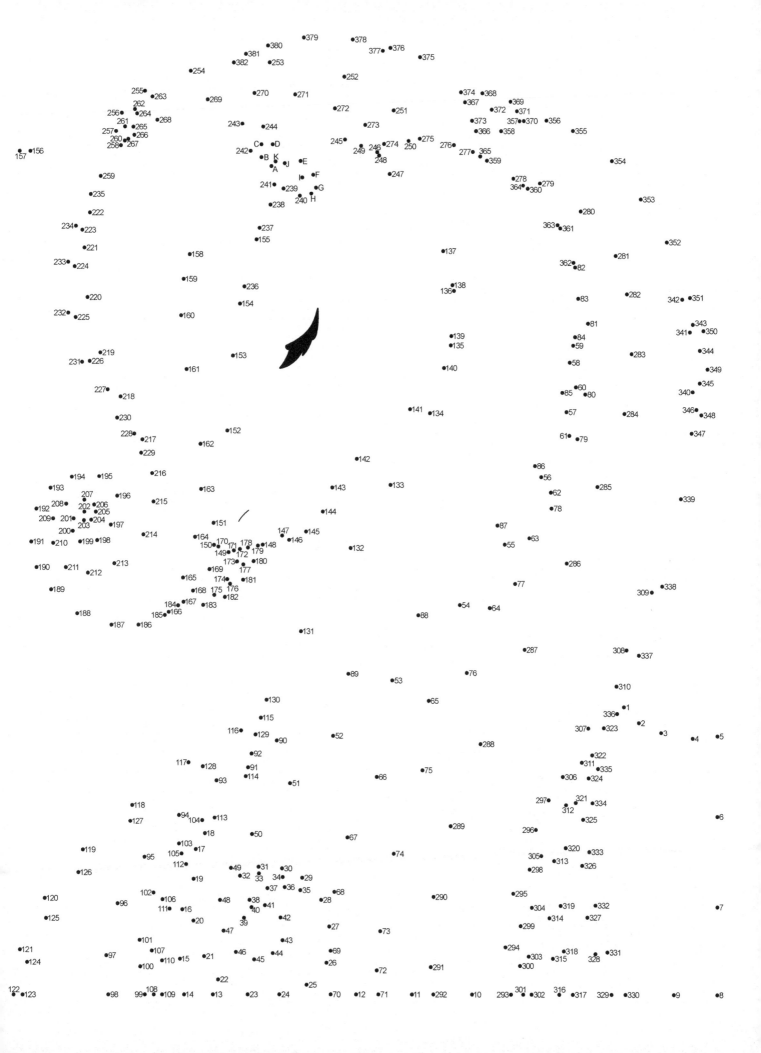

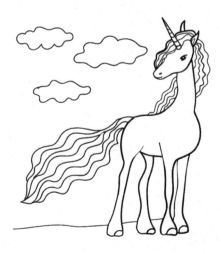

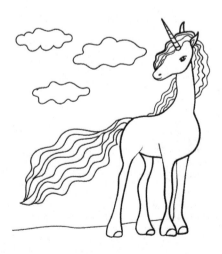

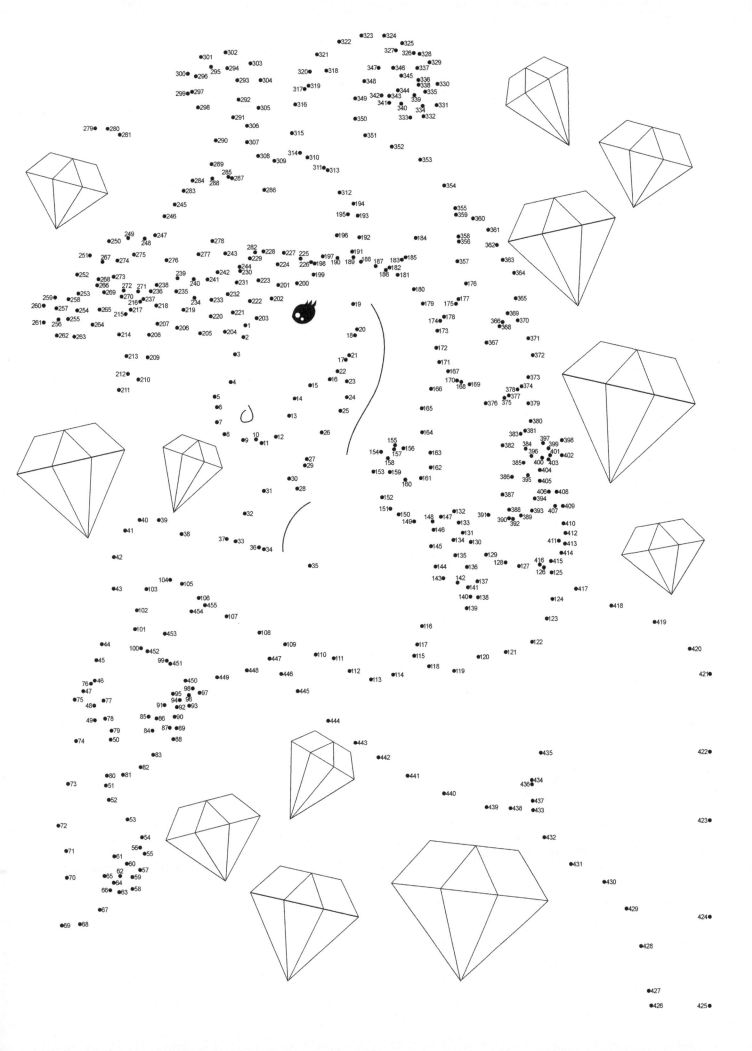

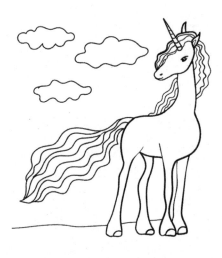

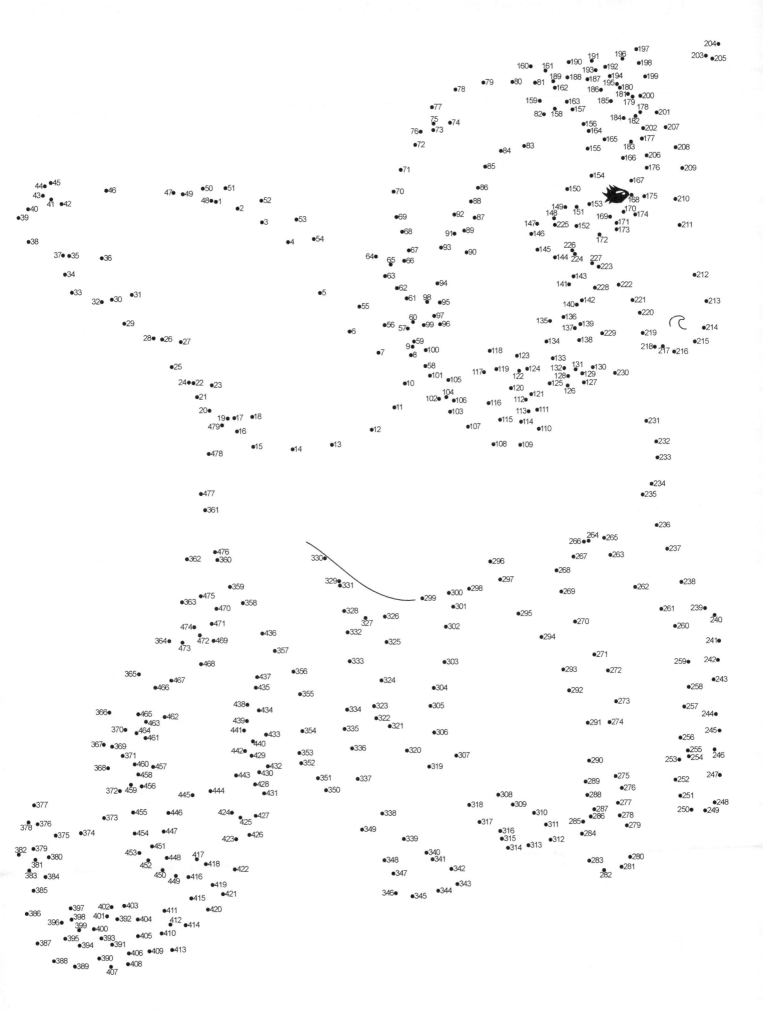

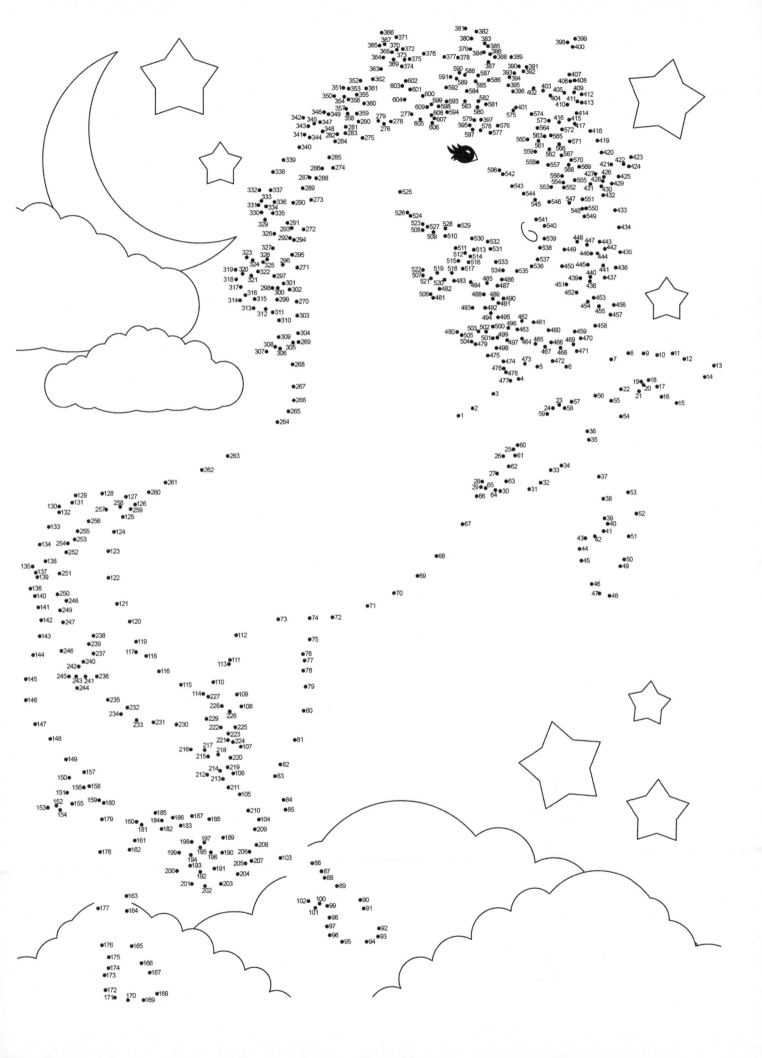

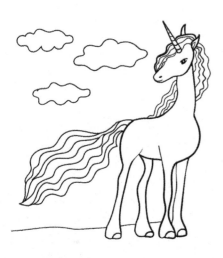

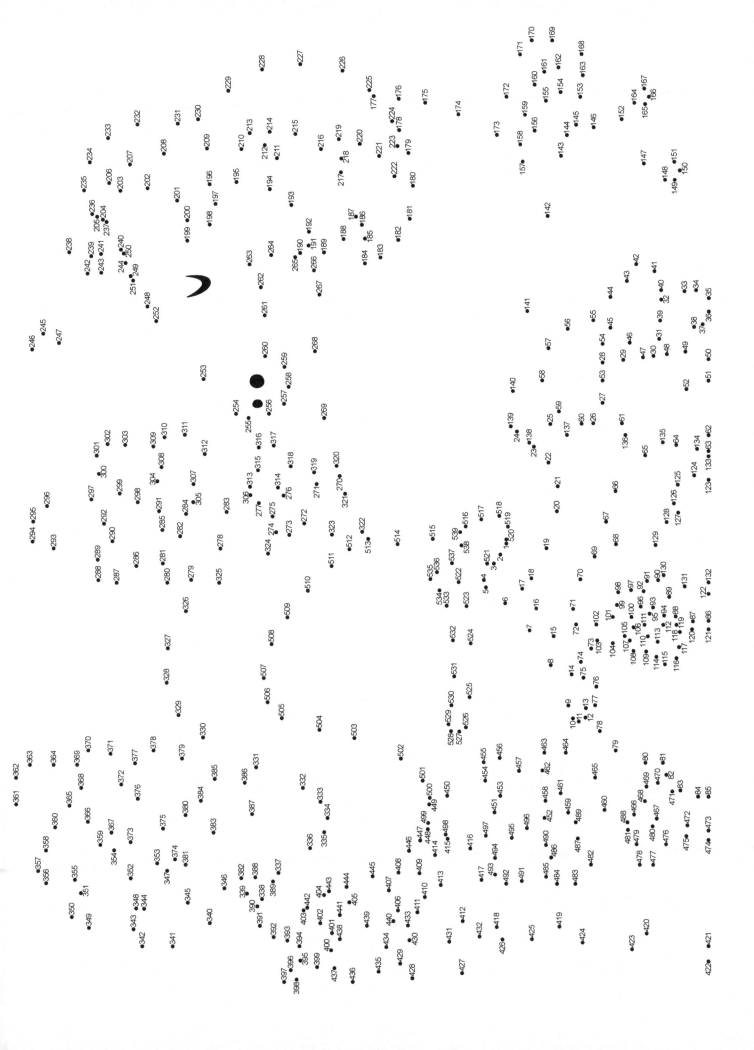

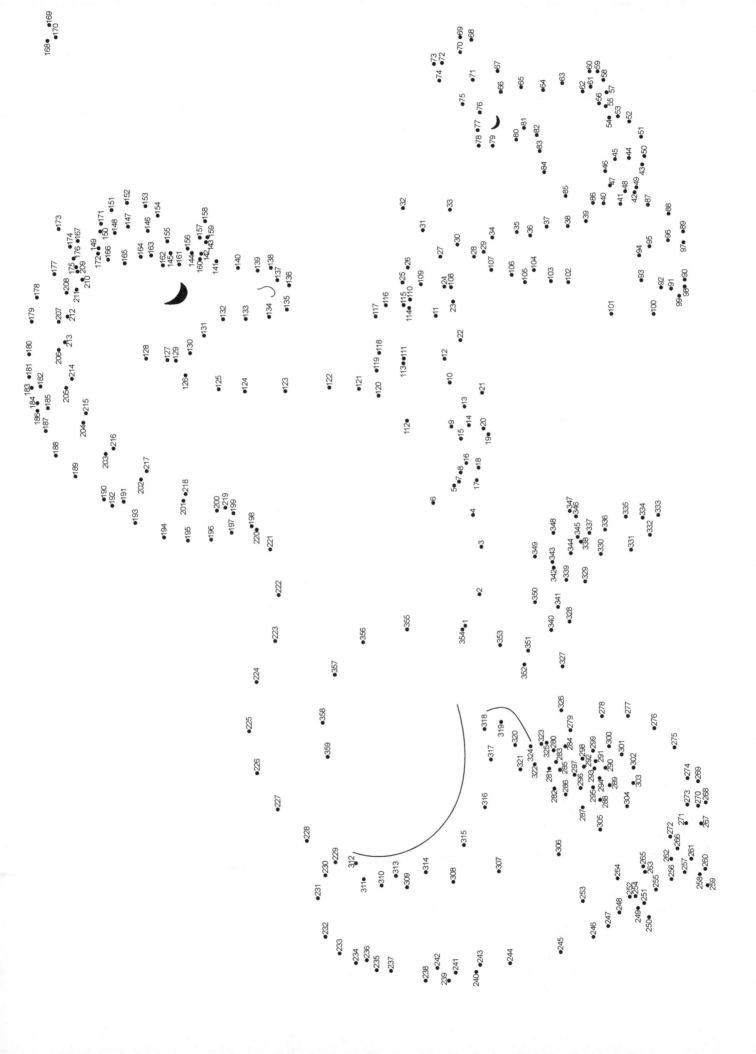

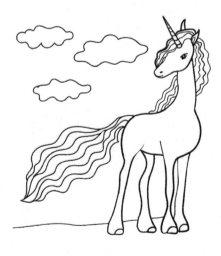

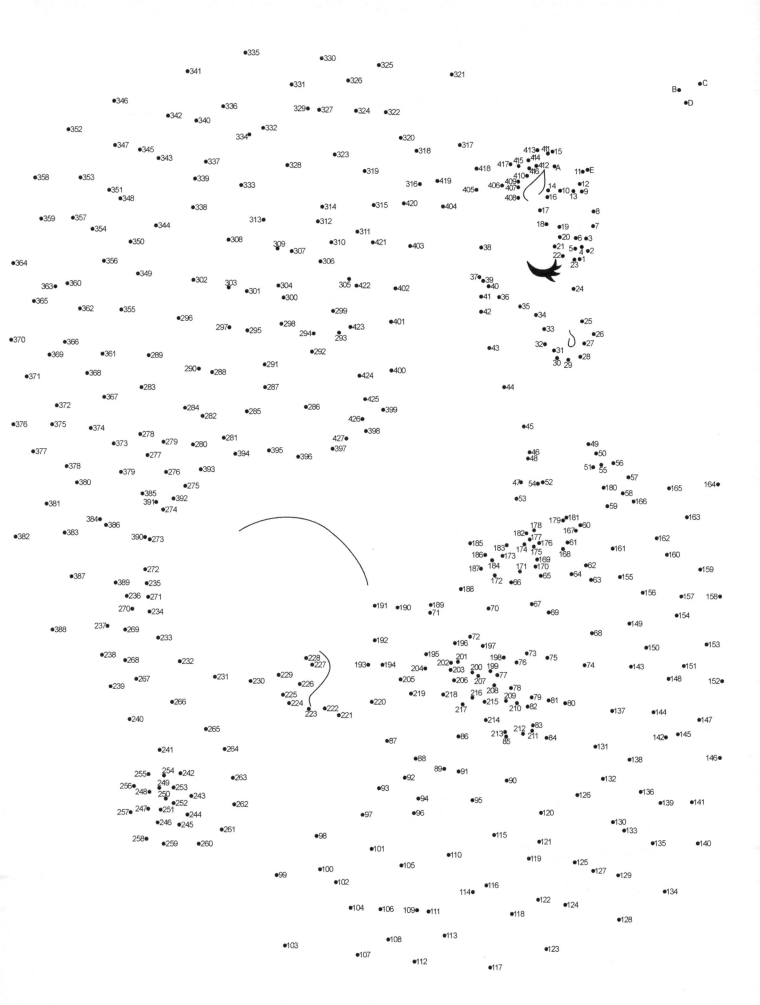

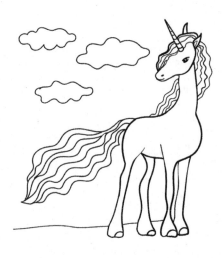

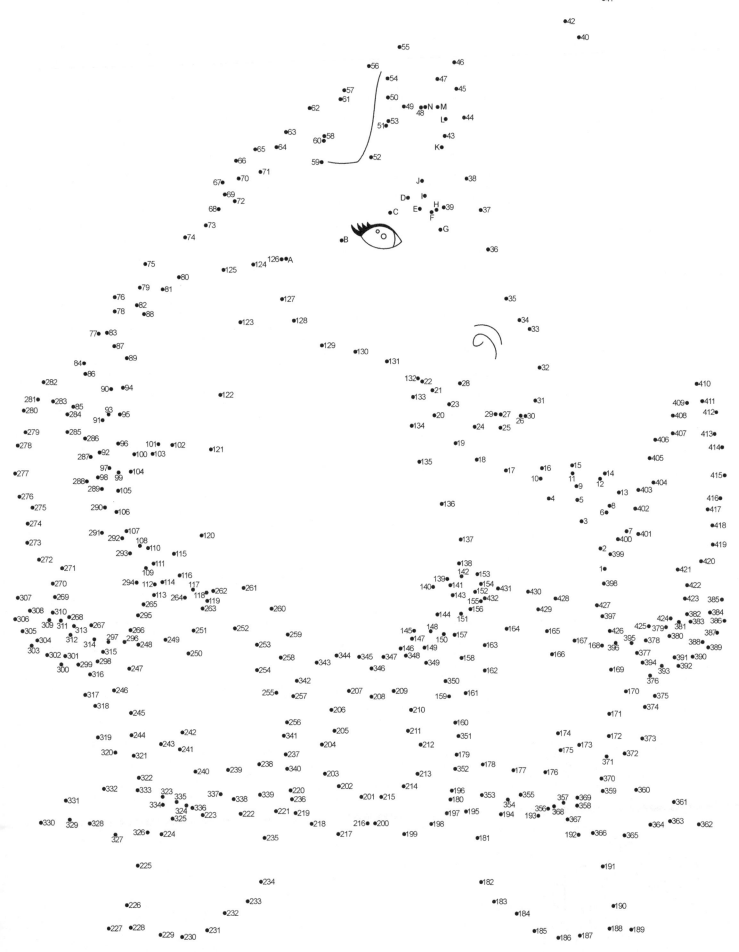

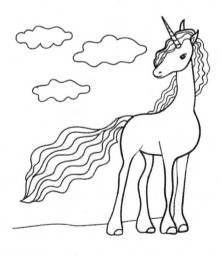

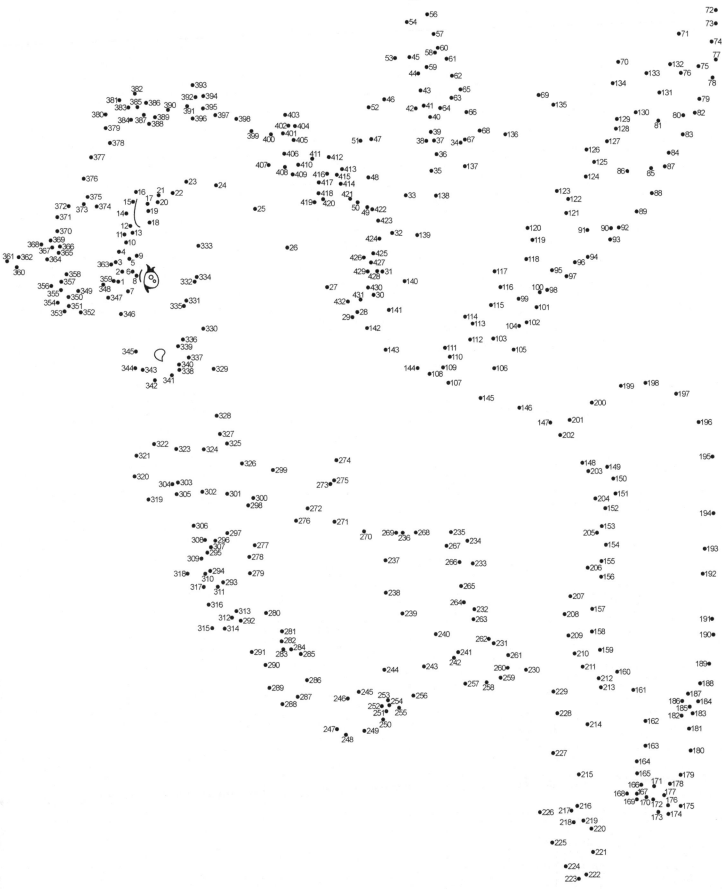

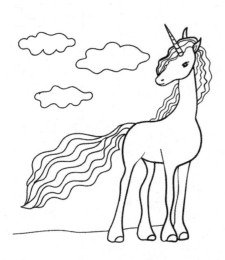

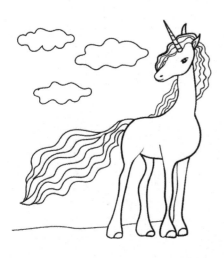

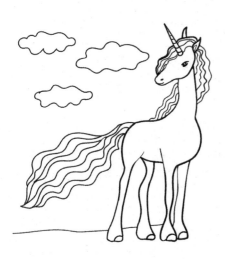

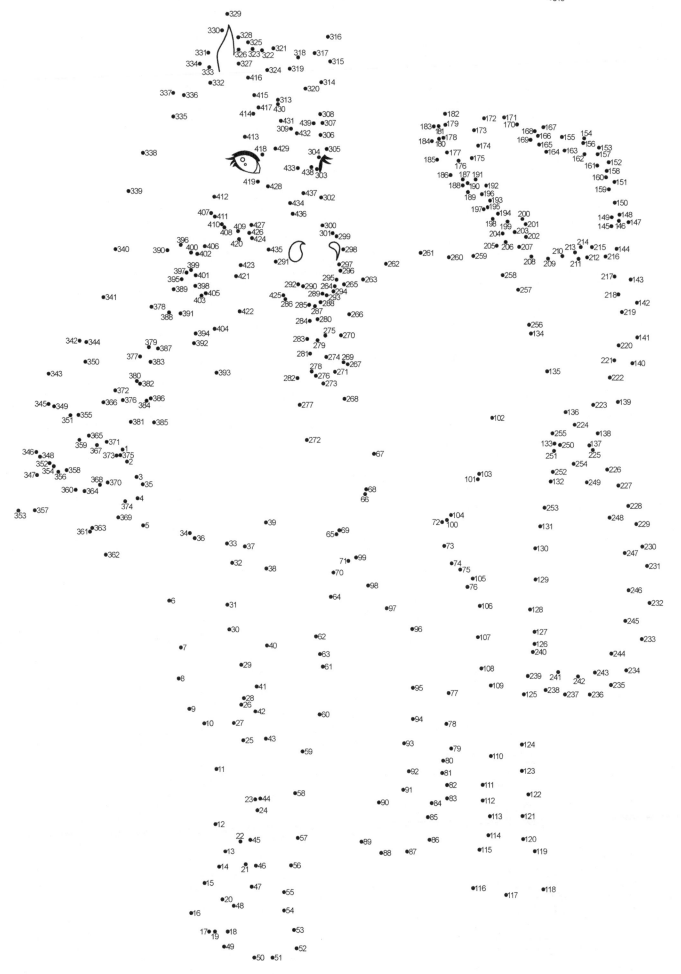

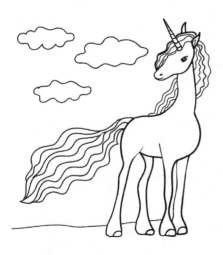

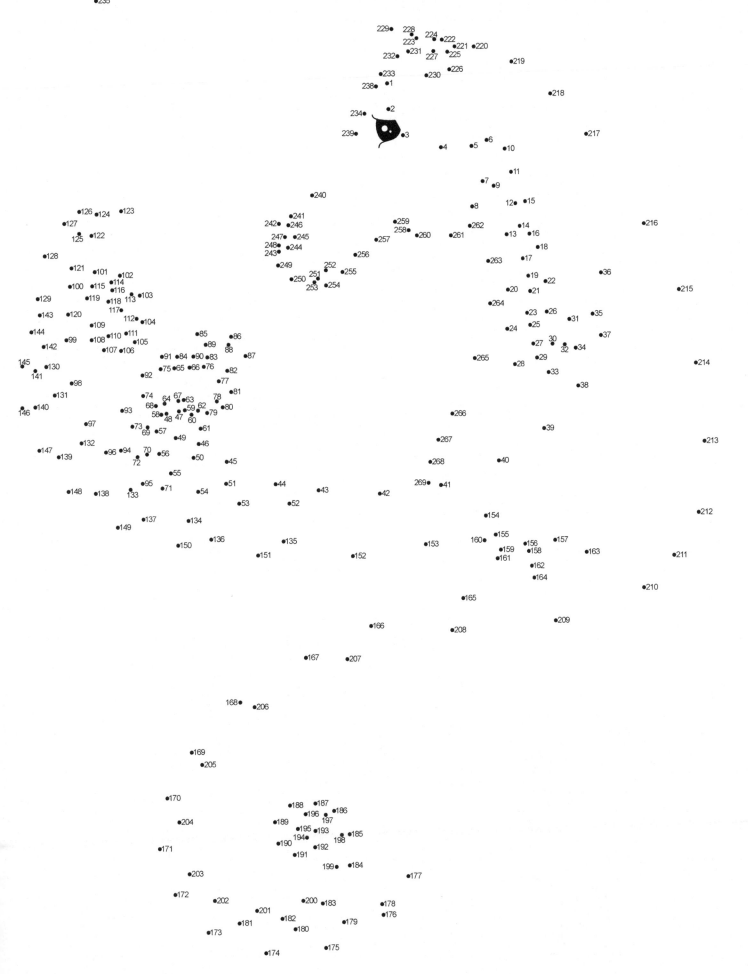

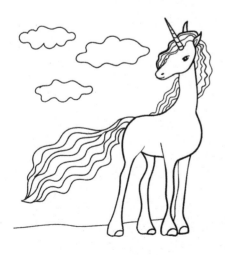

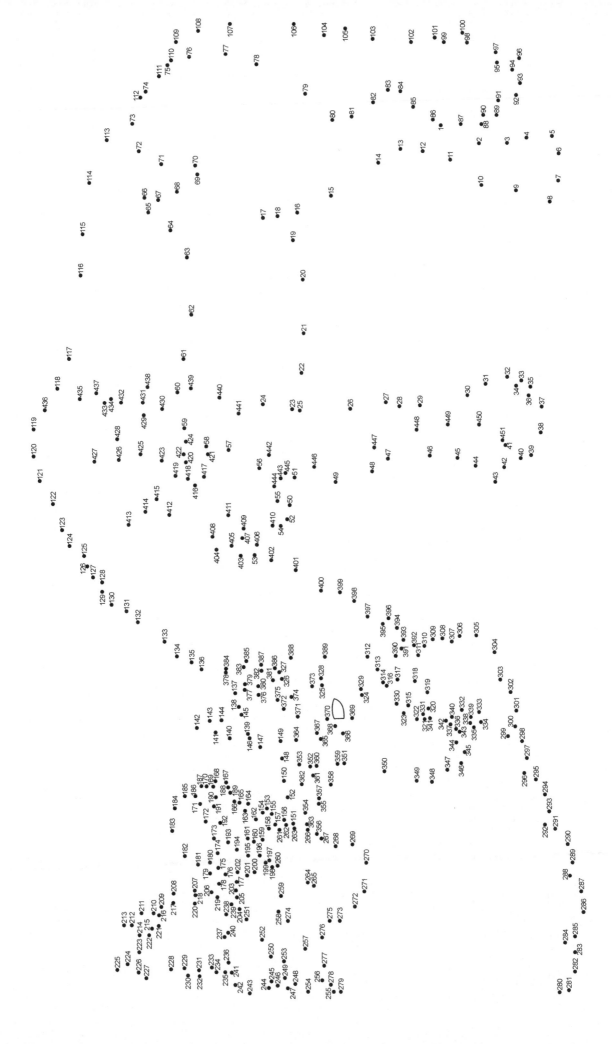

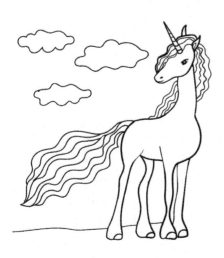

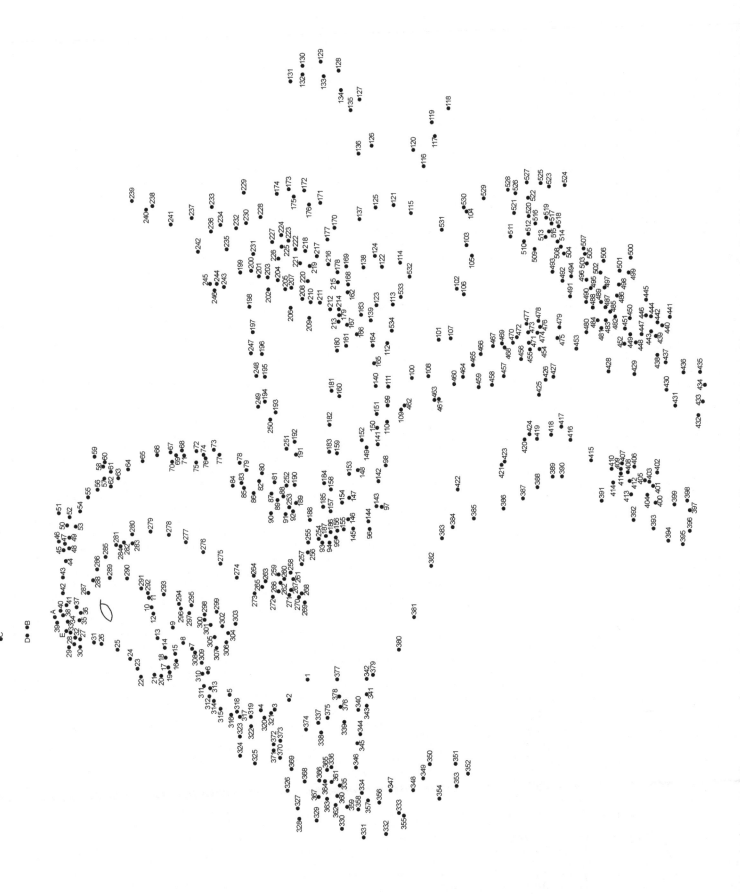

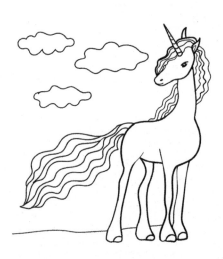

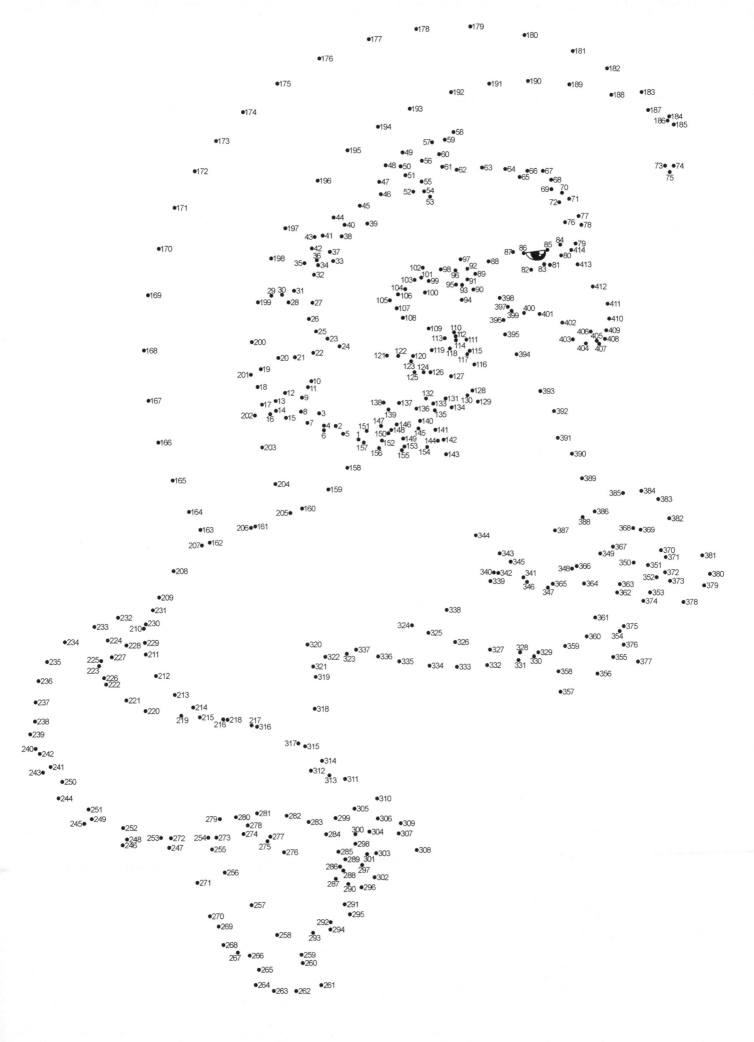

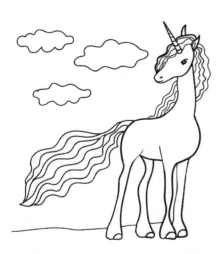

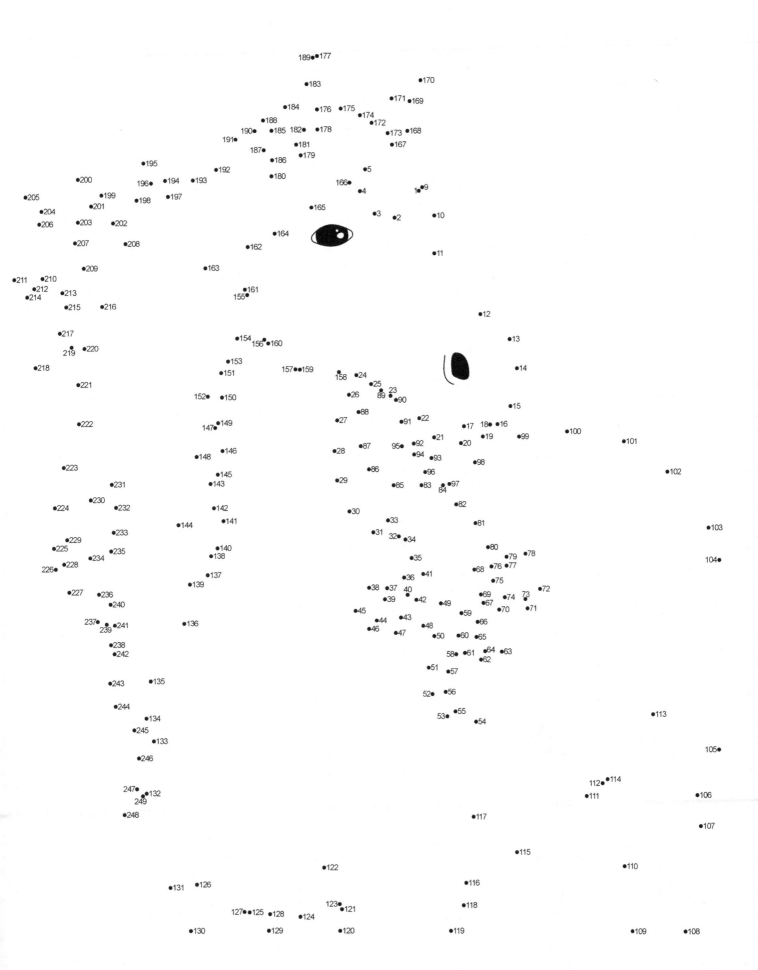

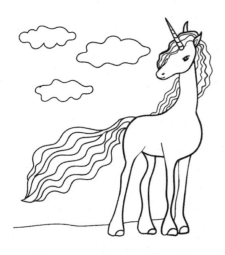

Made in the USA
Monee, IL
16 December 2019